THE LITTLE BOOK OF

# Wombat
# Wisdom

THE LITTLE BOOK OF

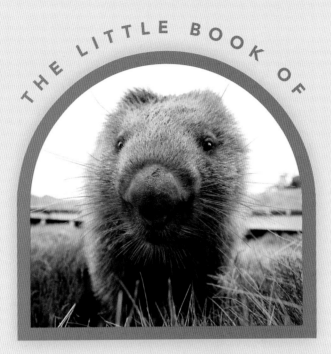

# Wombat
# Wisdom

HarperCollins*Publishers*

# introduction

Why should you take life advice from a big-bottomed marsupial? Because wombats have life sorted. It's no mistake their collective noun is 'a wisdom of wombats'. They're self-sufficient, amply rounded, adorable and independent. And while they're mostly pretty chill, they also aren't afraid to get feisty. Show me another animal who can crush their adversaries just by sitting on them. Big bottoms rule, okay? Also, their poo comes in very neat cubes.

So, enjoy words of wisdom from a low-to-the-ground perspective. From a contented, slow-moving, big-bottomed perspective. From an 'everything will be okay' perspective. From a 'life is actually mostly pretty good' perspective.

From the wisdom of wombats.

We may be a little shaggier and a little (ahem) heavier than when we were younger, but we can still enjoy just sitting in the warm sunshine.

# It's the little things that are important.

**Admit your true inner beauty.**

**Go on, say it: you're beautiful.**

Think back to a time when
you were young, curious
and knew nothing.

You went out into the world
carefree, happy, looking
for fun ... and food.

Don't be afraid to
be young again.
To be more 'young wombat'.

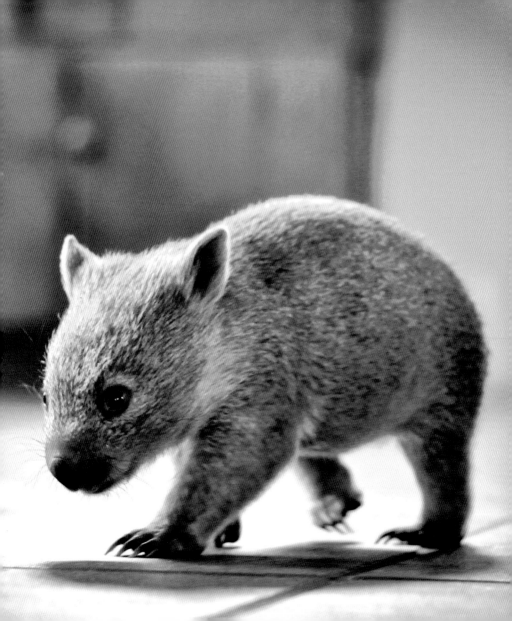

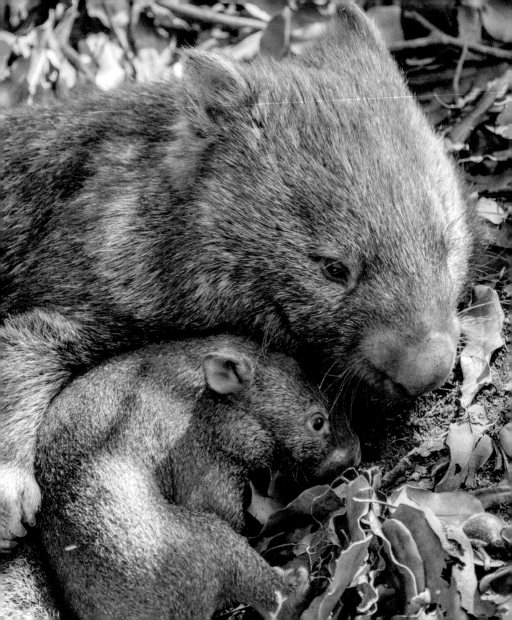

**Family is the best.**

**Keep them close.**

**Cuddle them often.**

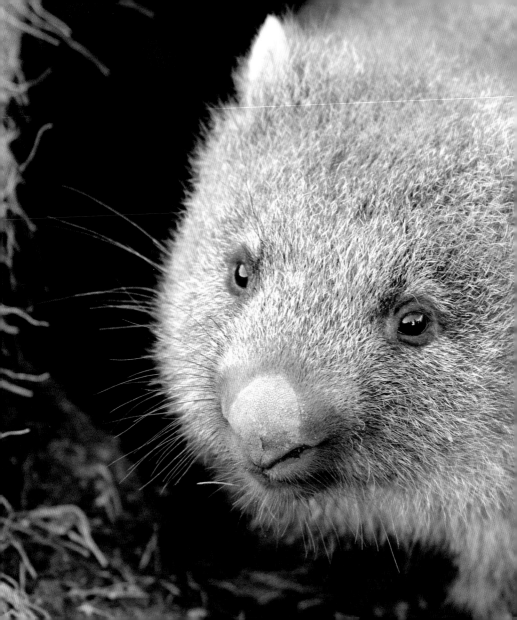

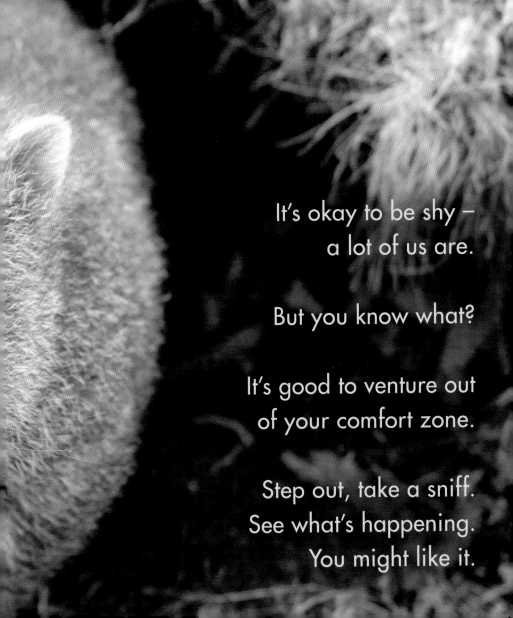

It's okay to be shy —
a lot of us are.

But you know what?

It's good to venture out
of your comfort zone.

Step out, take a sniff.
See what's happening.
You might like it.

# Staying curious is the secret to a long life.

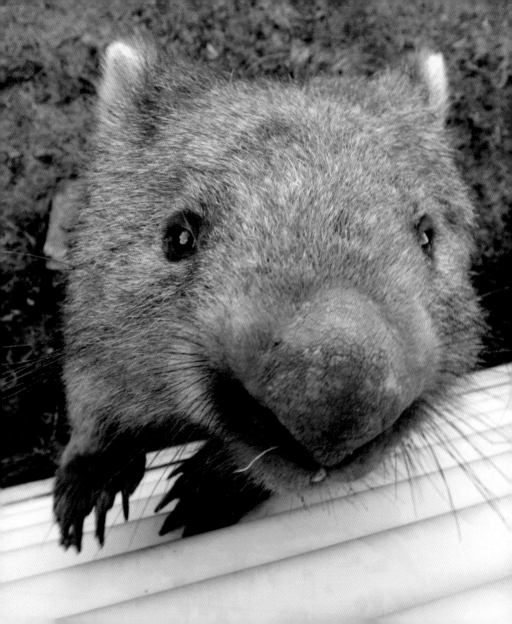

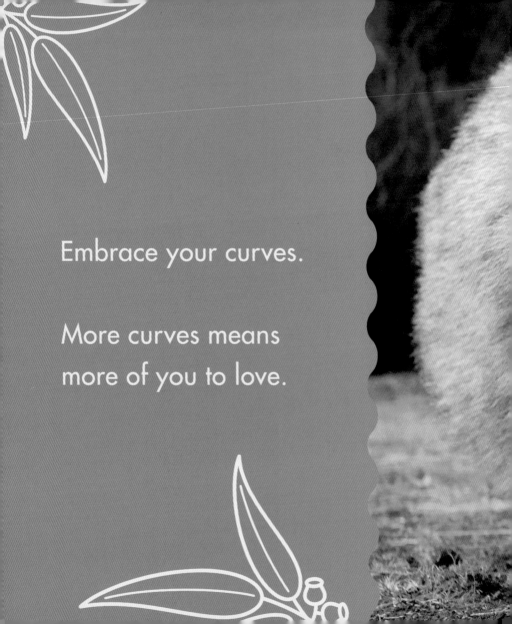

Embrace your curves.

More curves means
more of you to love.

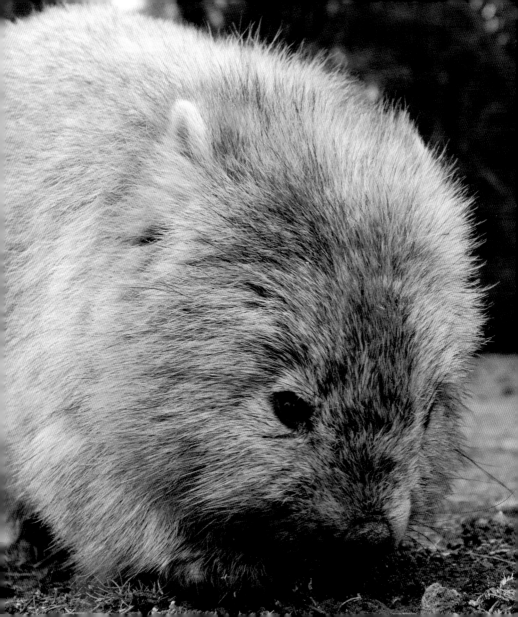

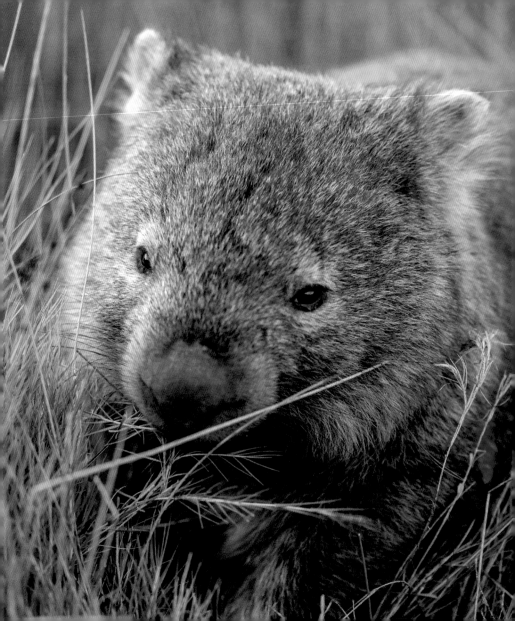

Sometimes, life might feel like you're lost in the long grass.

But it's okay not to know where you're going.

Have faith in yourself and the way will be revealed to you.

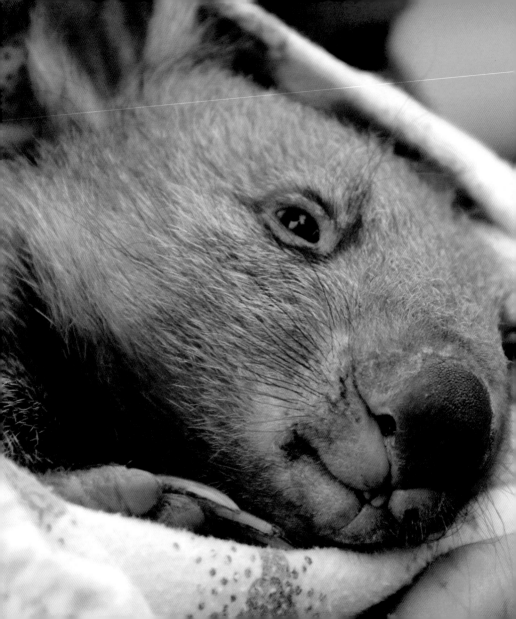

When times get tough, wrap
yourself up in a blanket and
remember what it was to be held,
safe and warm, and loved.

# You'll get through this.

Sometimes all we
need is a loving touch ...
or a little scratch
behind the ear.

It's the simple things,
isn't it?

Don't forget to
appreciate the people
who do it for you –
they're the best.

Table manners are
always important.

Do like your nana
told you: sit up
straight and don't
hog your food.
Use your knife and
fork 'proper like'.

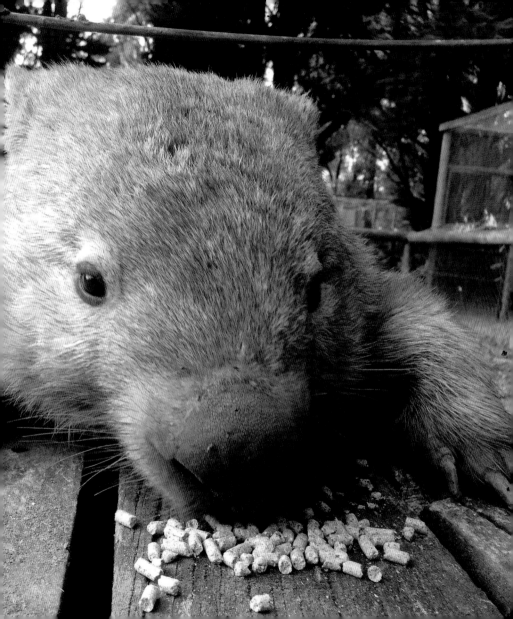

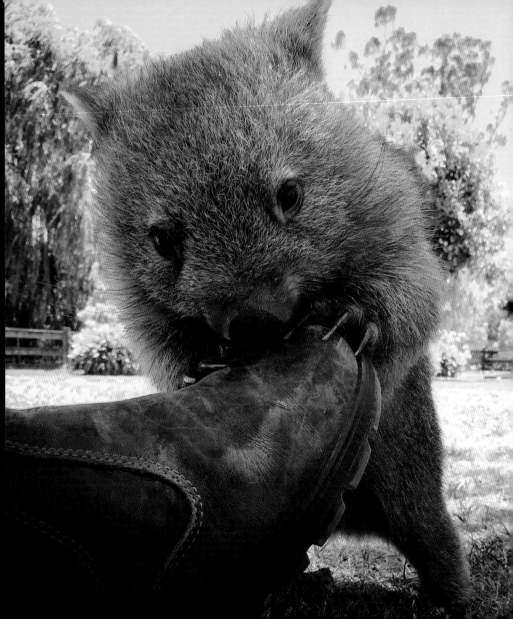

Are you nervous about
trying something new?

It's often good to try
things at least once.
Go on, have a go.

It probably won't kill you,
and you might learn something.

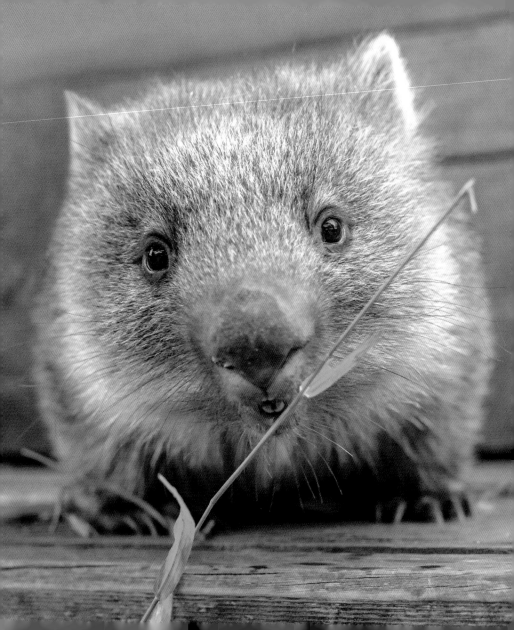

We all love hot chips.
They are the stuff of life.
But keeping up your vegie
intake is important too.

Eat green, eat often.

Sleep is good for you.

Always try to get your eight hours every night (or day).

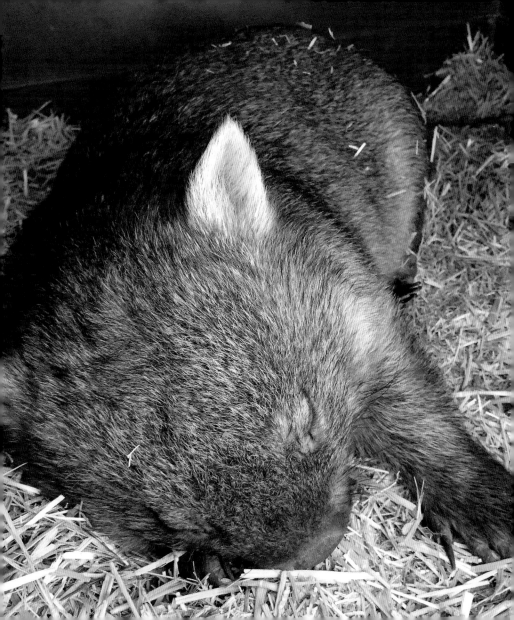

Find out what
you like to do,
then do it until
you get good at it.

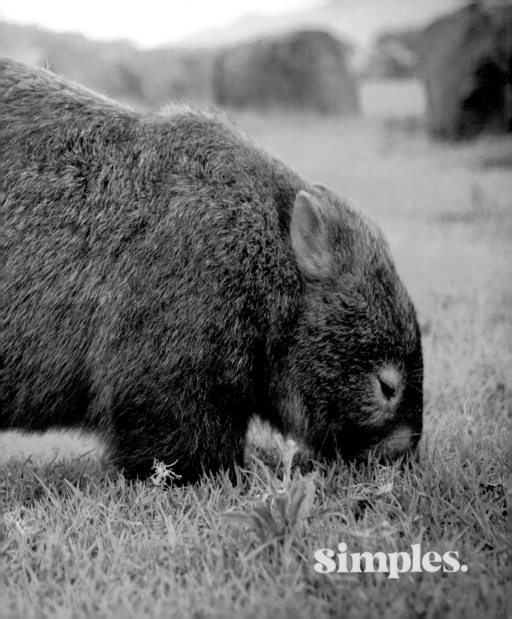

Simples.

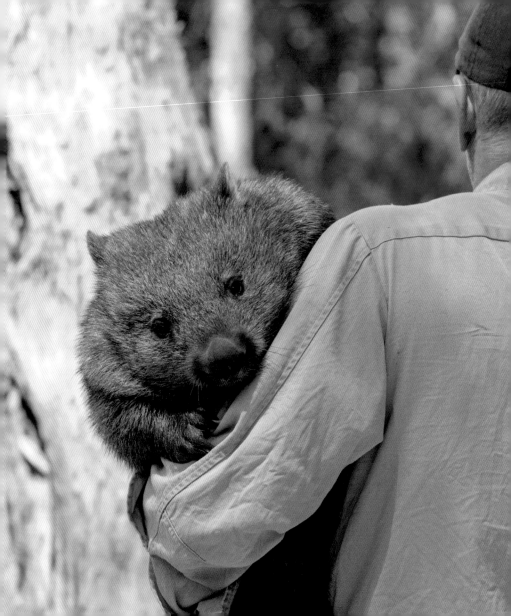

'Even under challenging circumstances, try to keep your dignity intact.

Damn straight, it's okay
to love yourself.

Especially when
you look this good,
you know?

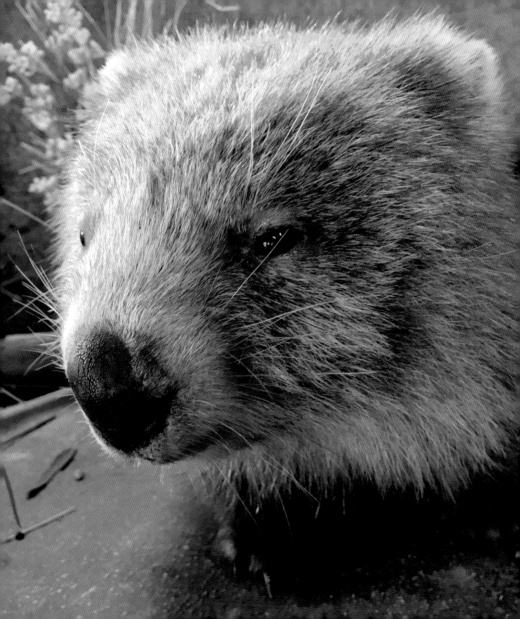

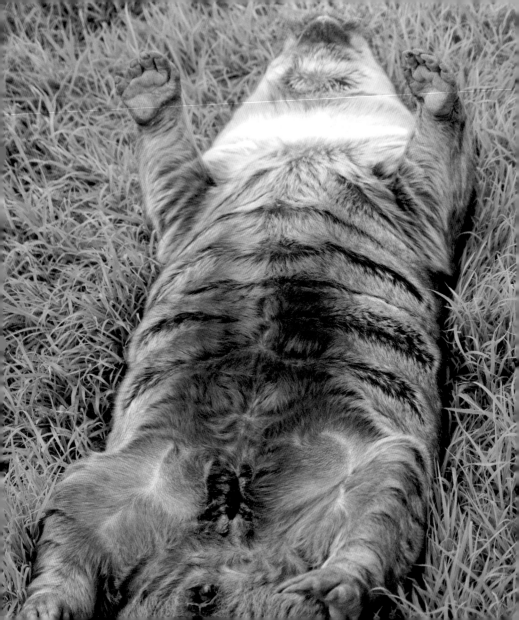

It's totally fine to let it all hang out sometimes.

It's your life.

Do what you want.

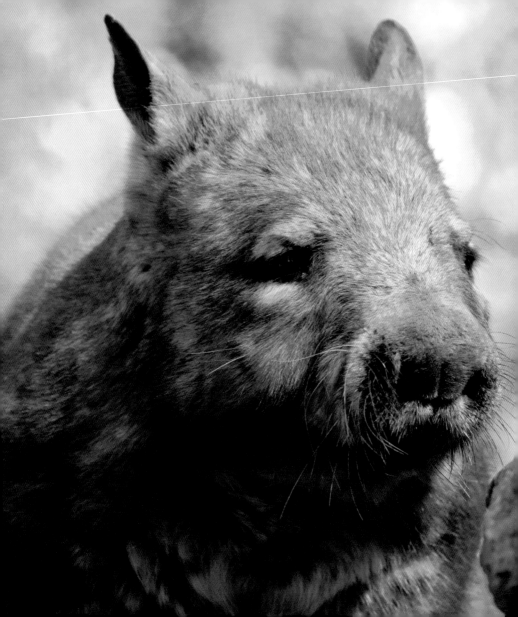

Life can be ...
a bit much
sometimes.

We get it.

But like
all things,
your troubles
will eventually
pass.

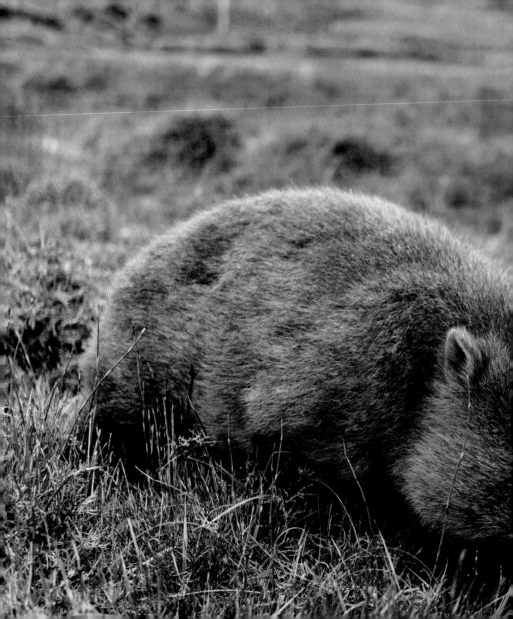

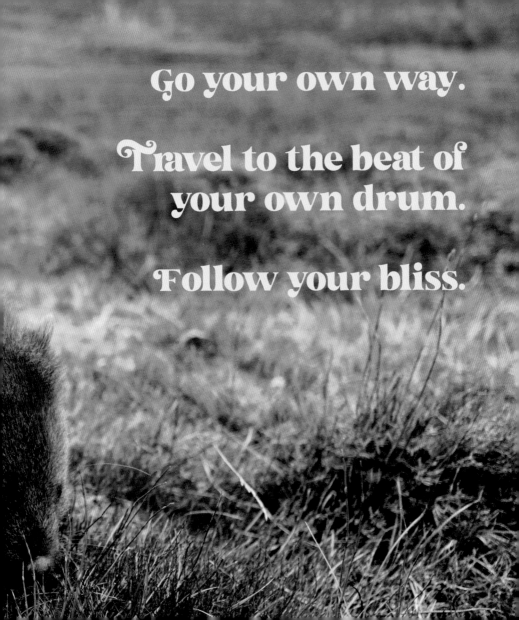

Go your own way.

Travel to the beat of your own drum.

Follow your bliss.

'We were all
small once.

'Be gentle with
small ones, and
with yourself.

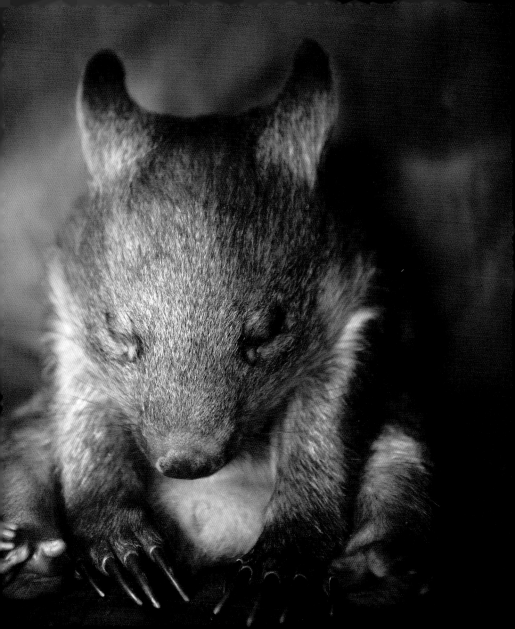

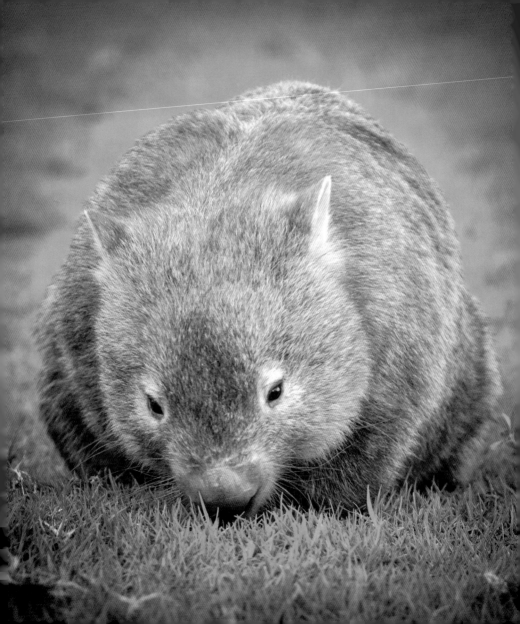

You are
adorable,
exactly the
size and
shape you are.

Just remember
that.

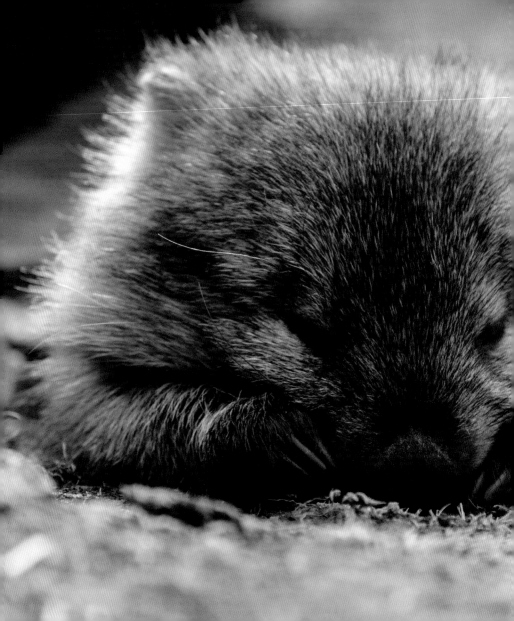

Some days you might not want to leave the house. You know what?

That's perfectly okay.

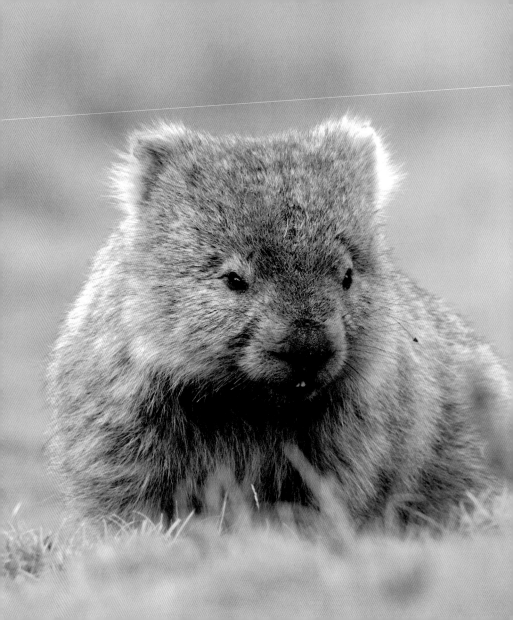

But, if you listen carefully, the world is alive with the sound of ... possibility.

So, some days, you might also want to get out there and see what life has to offer.

# Life is good!

# Enjoy it,
# seize the day,
# go on!

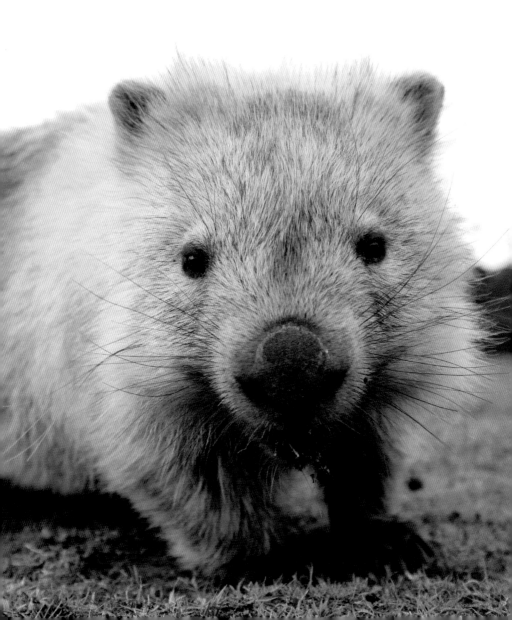

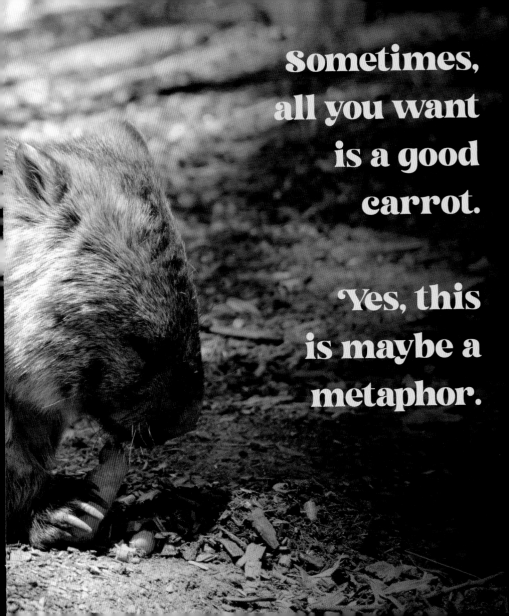

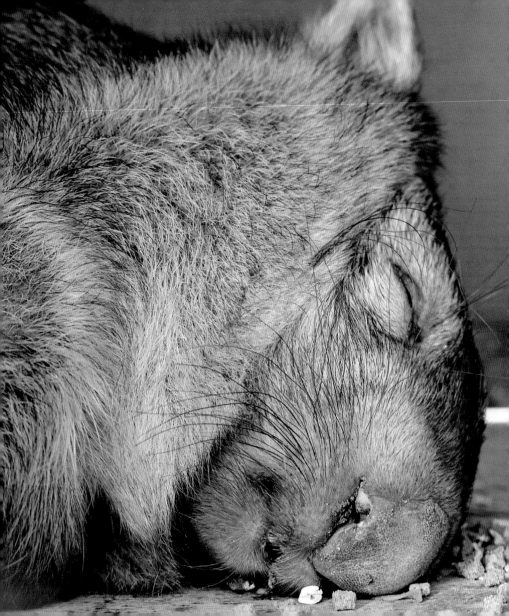

Try not to work so hard you fall asleep into your dinner. It isn't worth it.

(Also, it isn't a good look.)

There is nothing (nothing!) like a good cuddle.

Enjoy them whenever you can.

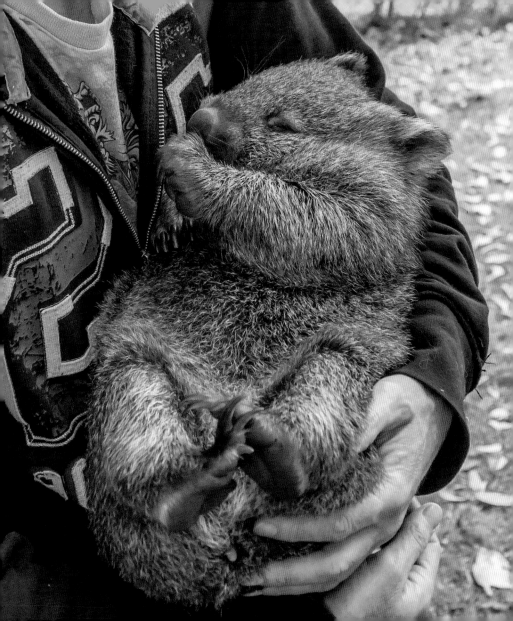

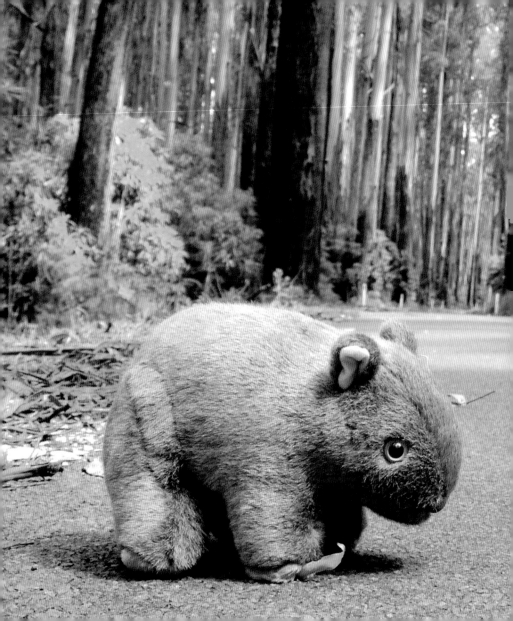

Always know
your good side,
especially when going
somewhere you expect
to be photographed.
It's okay to practise in
the mirror.

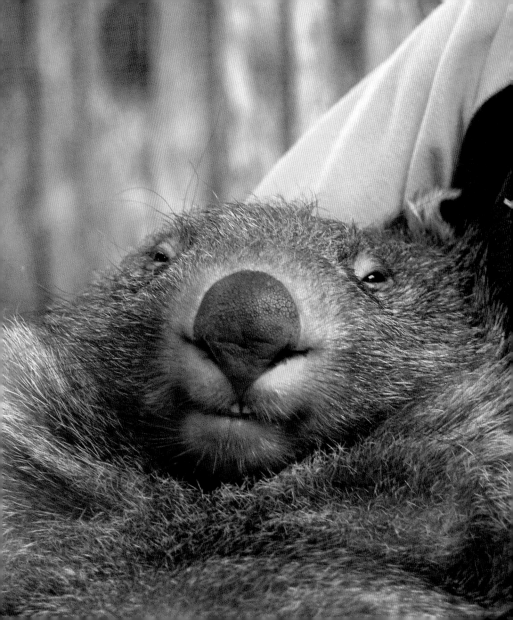

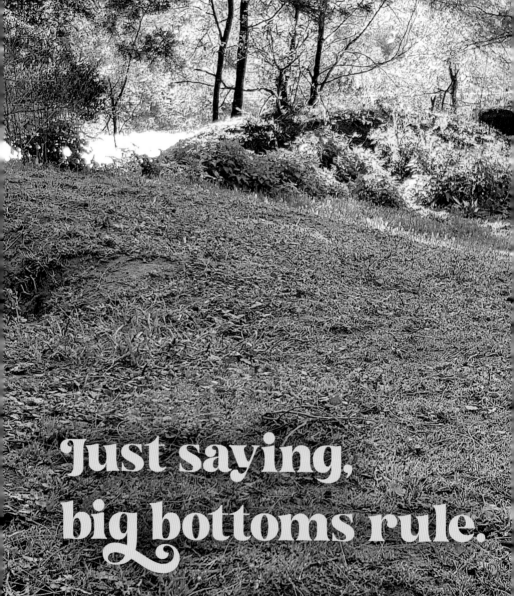

Just saying,
big bottoms rule.

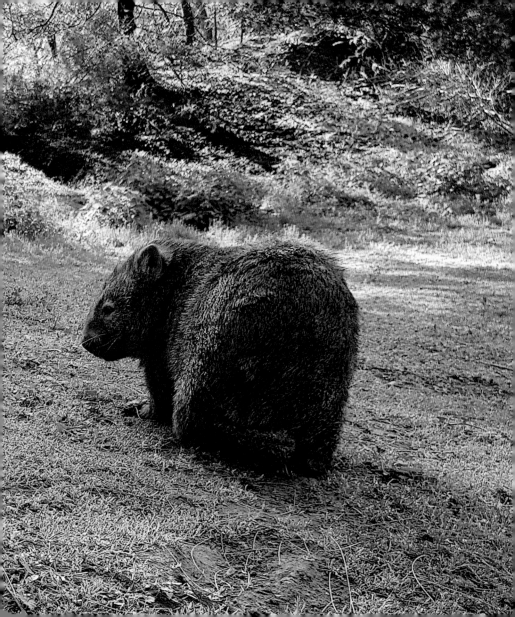

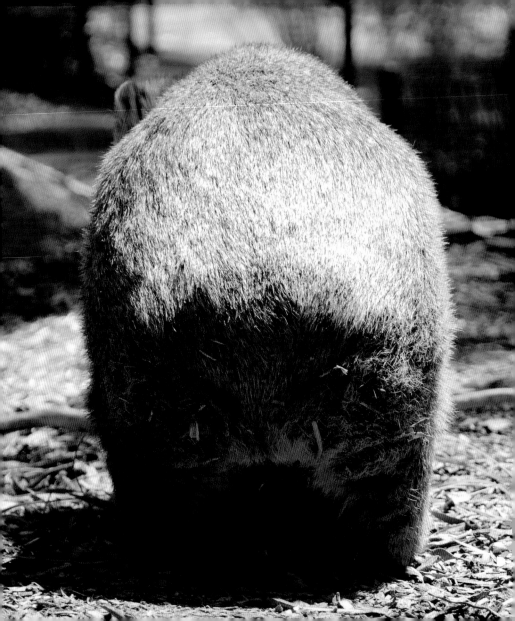

# And we mean big, baby.

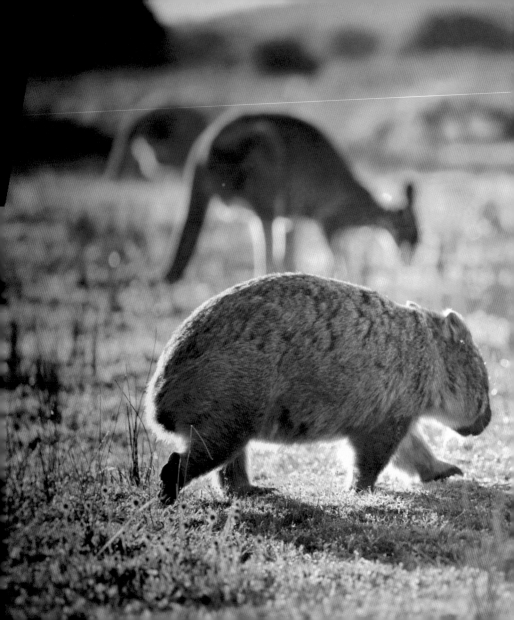

Want to know the secret of life?

Friends, family, fresh air, good food and a bit of exercise.

Always be kind to your mum.

Being a mother is a lot, sometimes.

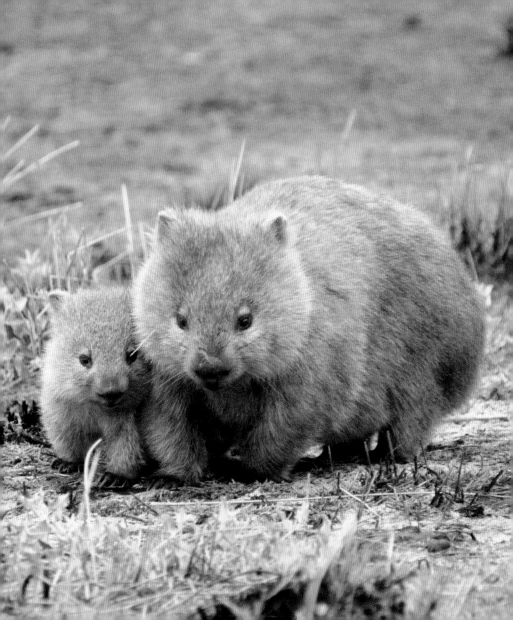

# The world is very big and we are all very small.

(But roses are also small, so get out there and smell them.)

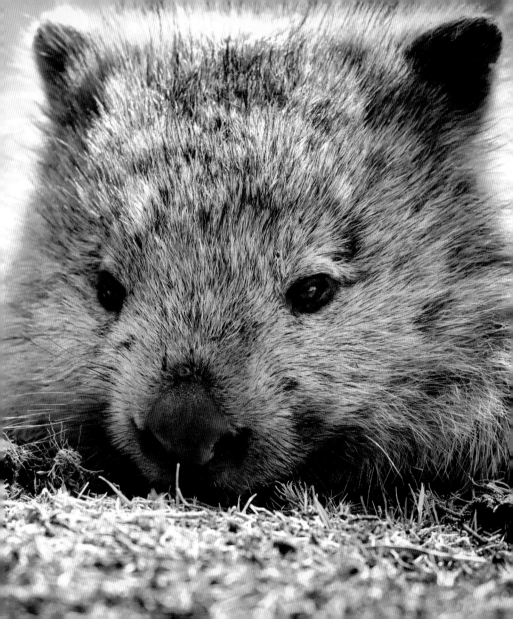

Even on the
busiest of days,
it's important to have
a bit of a sit and think.
Contemplate the
mysteries of the universe
… or decide what you're
going to eat for lunch.

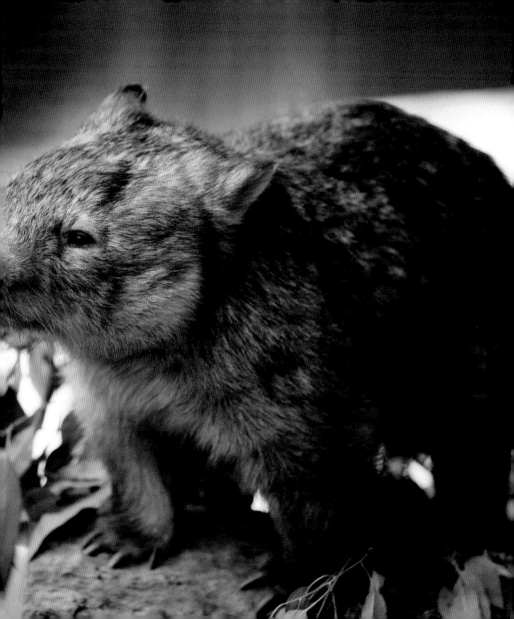

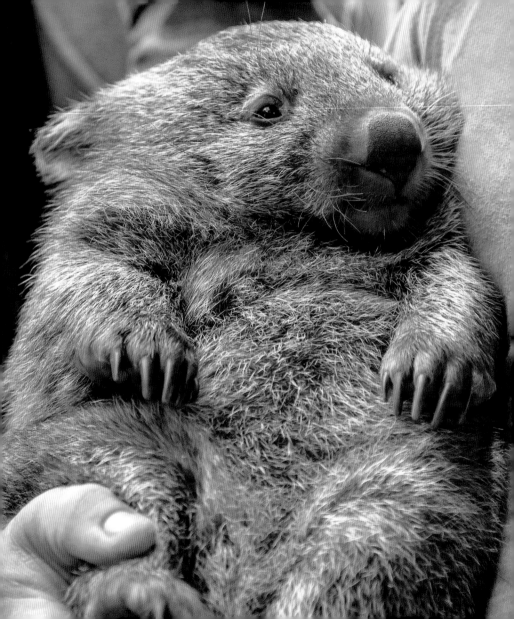

'We all need
and are
deserving
of love.

♥

Don't always accept what life offers you first. Take time to sniff around for something better – who knows what you'll find?

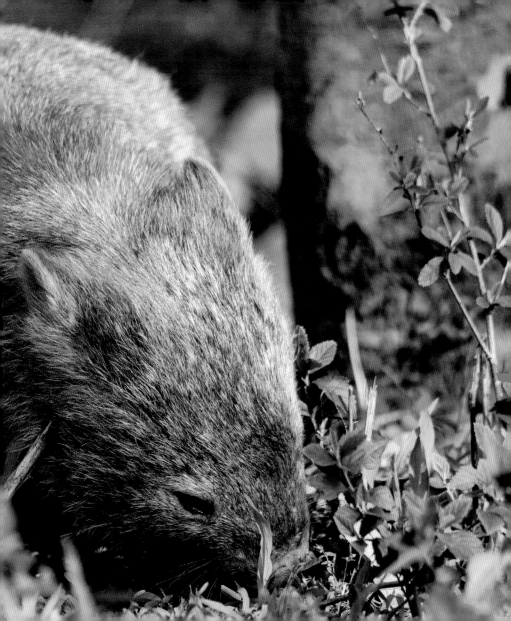

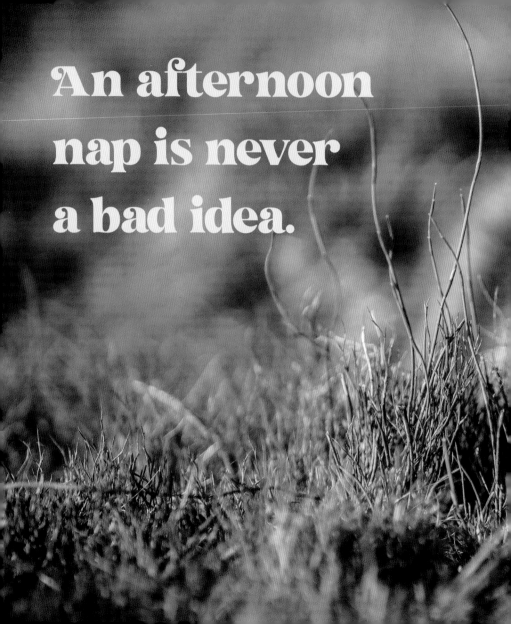

An afternoon nap is never a bad idea.

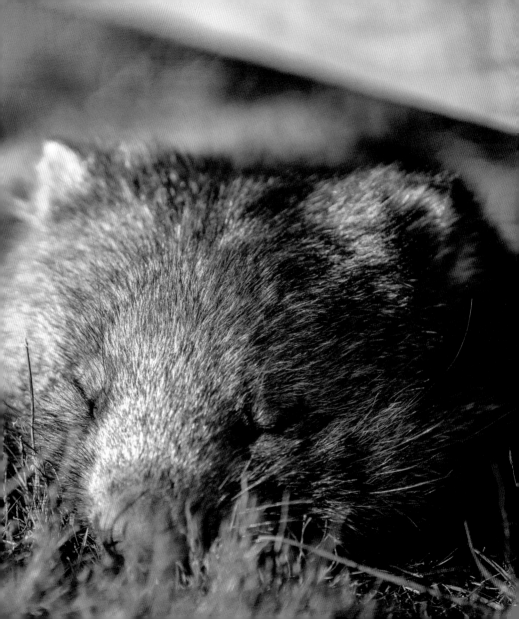

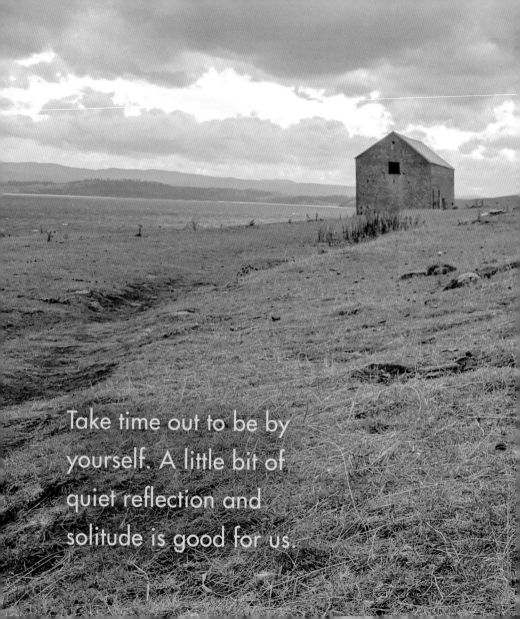

Take time out to be by
yourself. A little bit of
quiet reflection and
solitude is good for us.

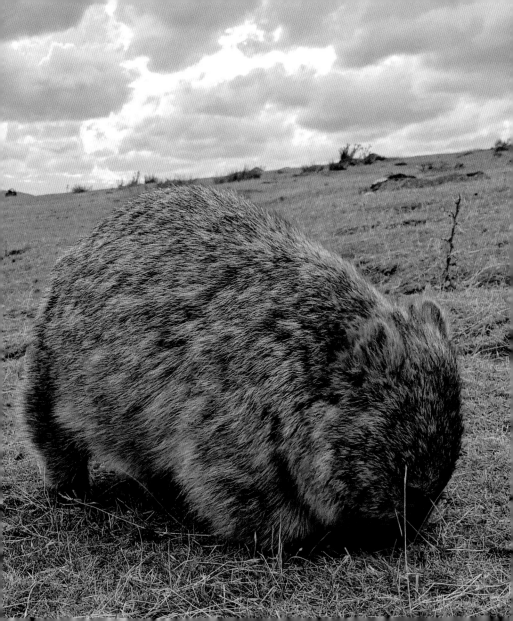

# Have we mentioned the importance of sleep?

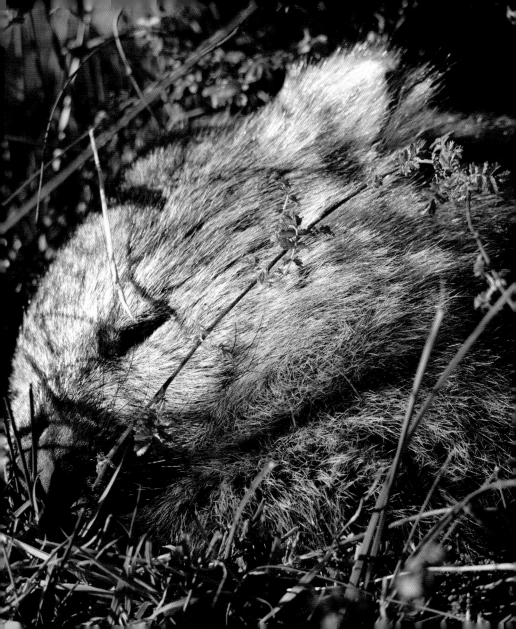

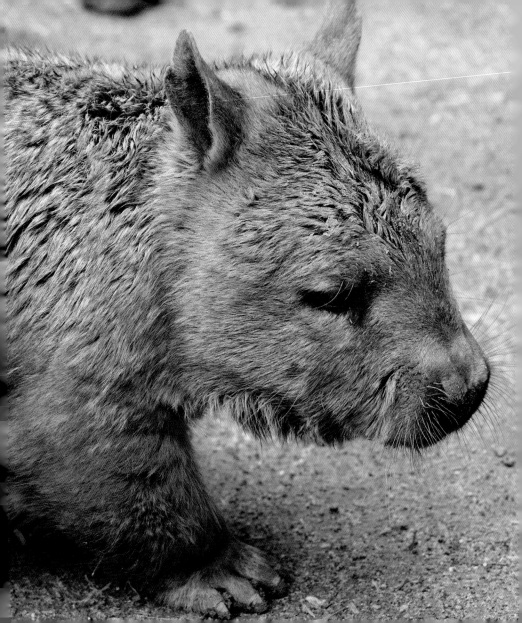

# Some days you win, some days you feel ... meh.

# Just keep going.

It's true what they say:

Smile and the world will smile back at you.

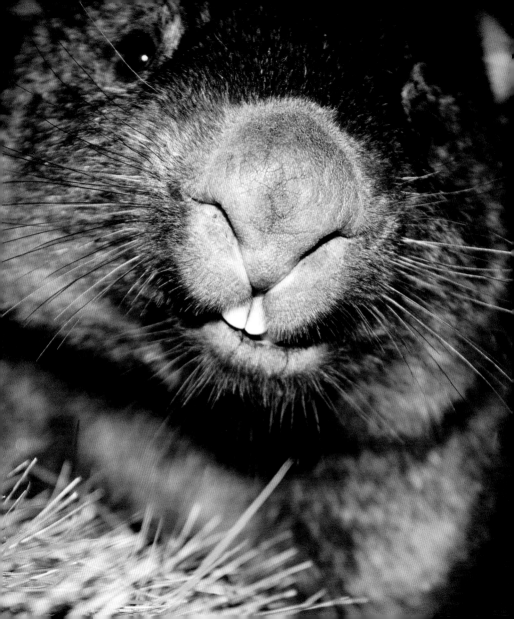

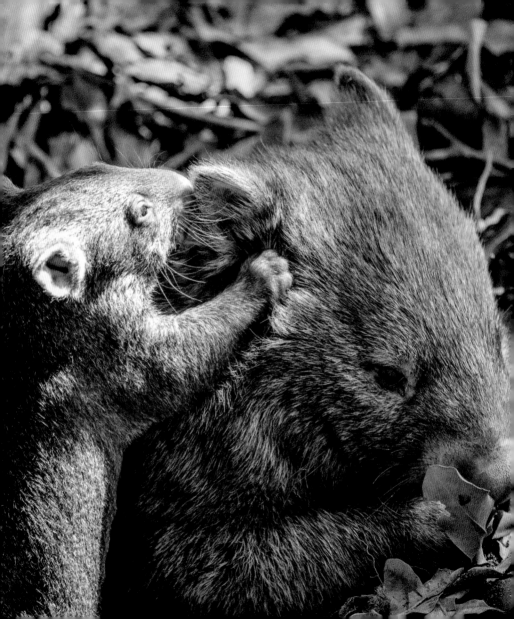

A word to the wise: don't get in your mum's hair when she's trying to do something important. It never ends well.

**Enthusiasm
is everything.
Embrace life
and it will
embrace you.
Eventually.**

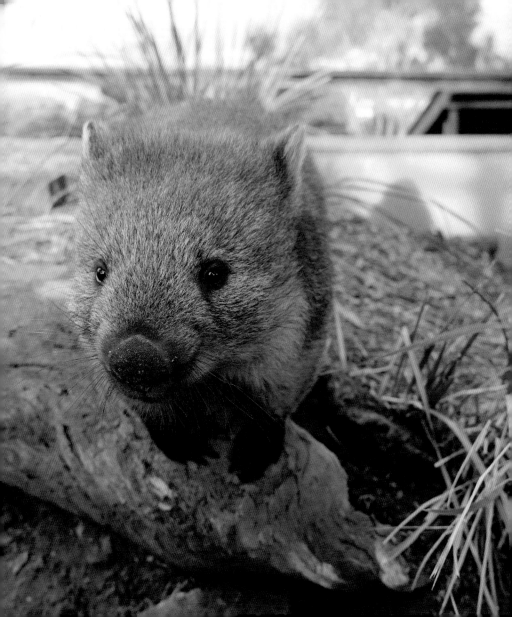

To the adventurous,
mountains are there to be
climbed, creeks are there to
be forged. Your dreams will
be waiting for you at the end.

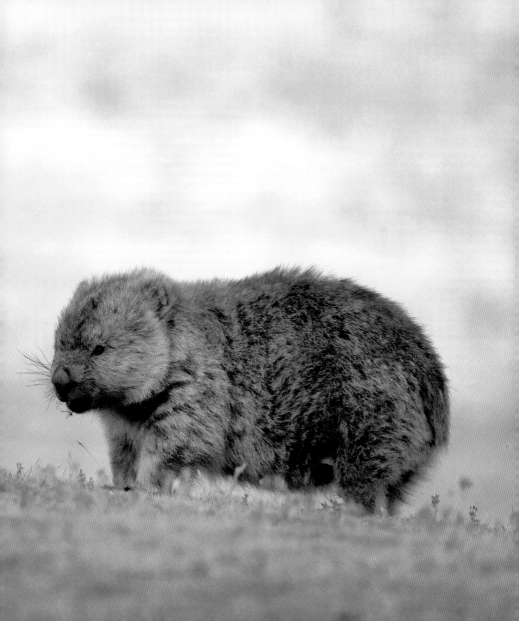

Life can land you in
some tricky situations.

Keep calm, don't panic.

Often, a new perspective
presents a new solution.

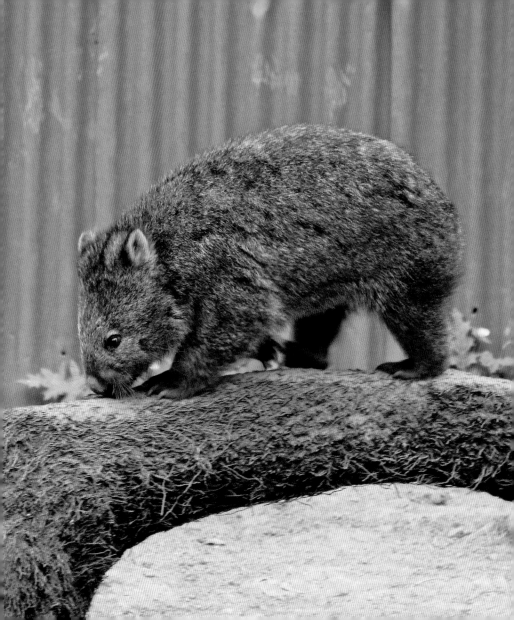

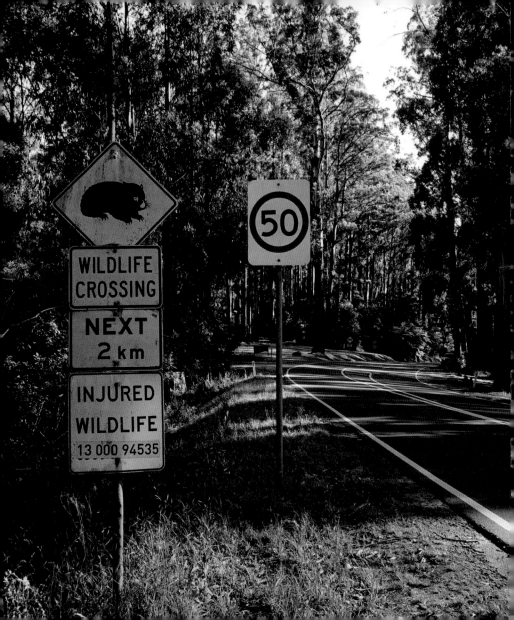

# Please be considerate and look out for others.

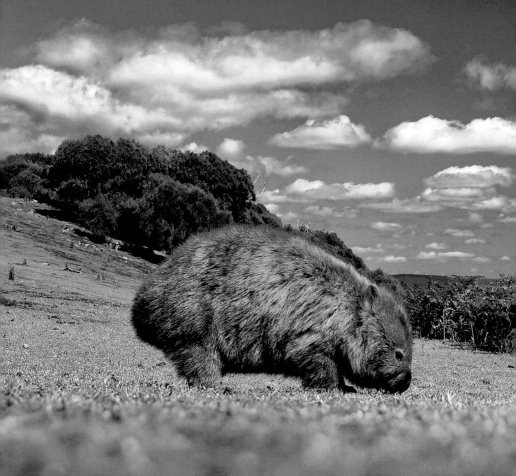

Ah, me. It's pretty good sometimes, isn't it?

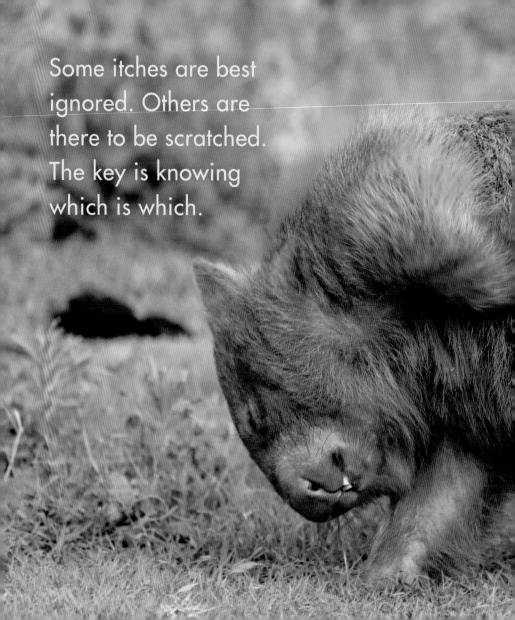

Some itches are best ignored. Others are there to be scratched. The key is knowing which is which.

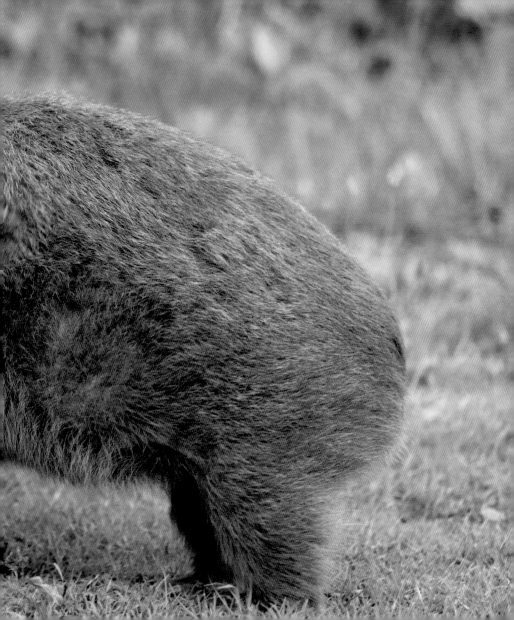

Life is a
balancing act.
Keep calm,
breathe, focus
and put one
foot in front
of the other.
You can do it.

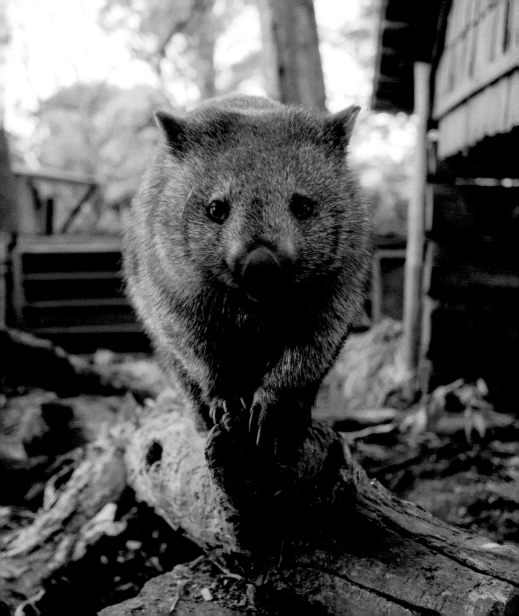

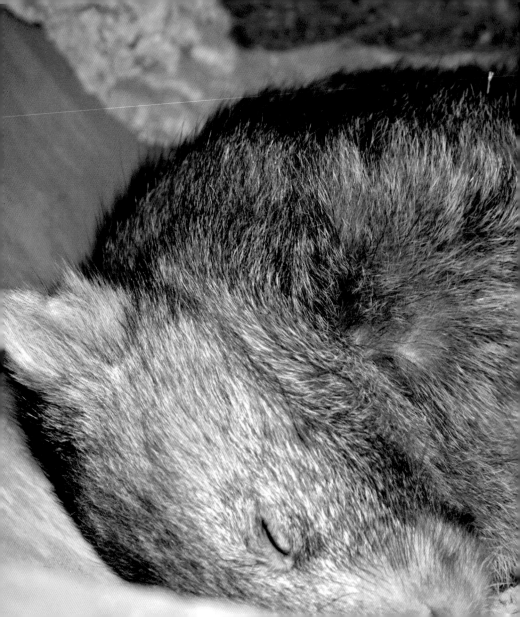

But some days ... yeah, we get it. Some days it's all you can do to stagger home and go to sleep. That's okay too.

'The biggest journeys started with a single step.'

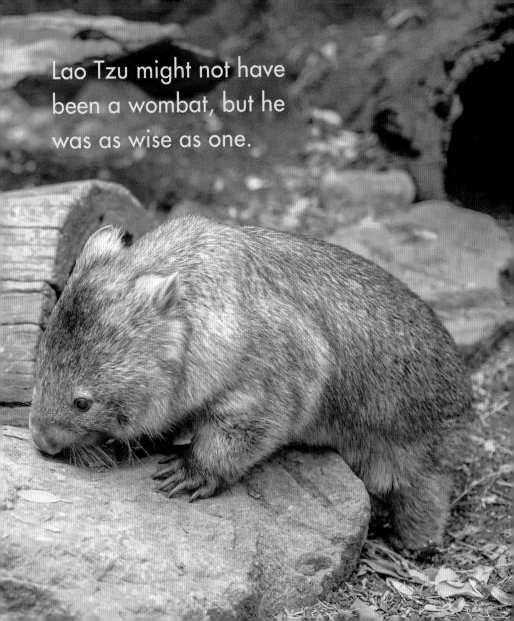

Lao Tzu might not have been a wombat, but he was as wise as one.

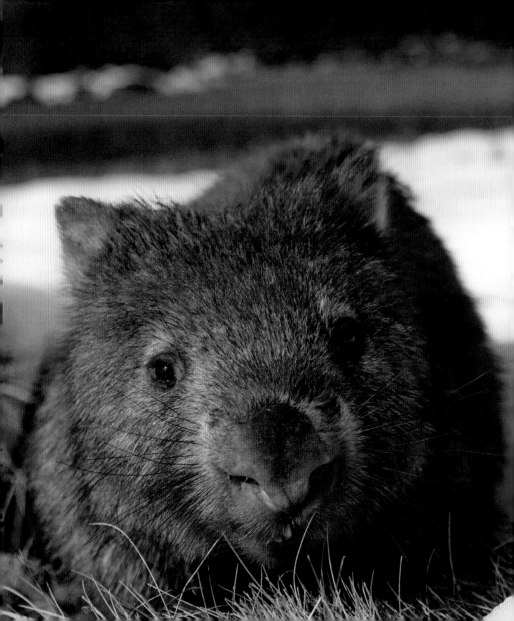

It's good to be honest with people. Sometimes you need to assert yourself and say:

'This is me –
if you don't like it,
you can lump it.'

'You can't make something without getting a bit messy.

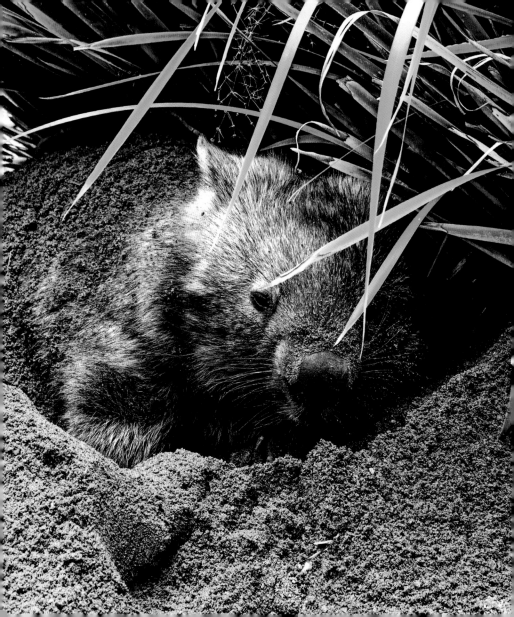

People will stare
at you sometimes.
That's okay. Let them.
You know they're
all wishing they
were more like you.
Because you, my
friend, are adorable.

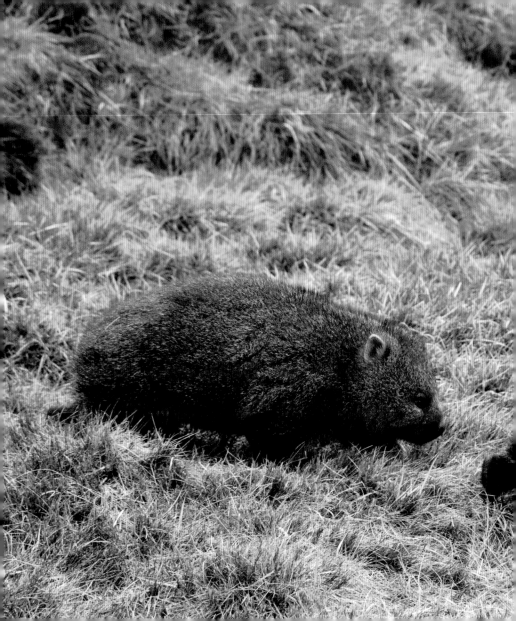

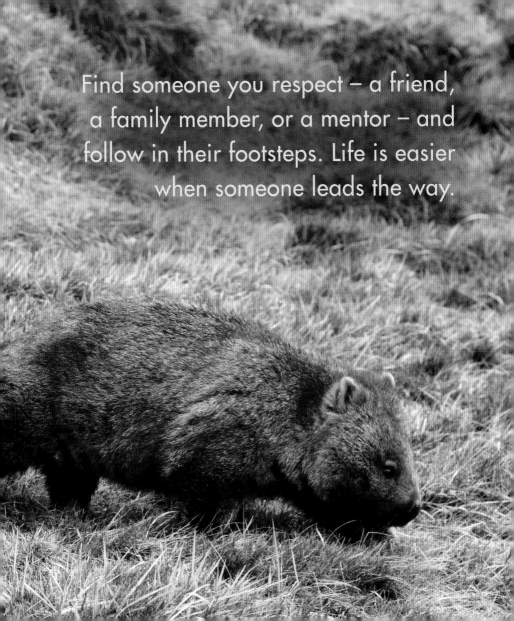

Find someone you respect — a friend, a family member, or a mentor — and follow in their footsteps. Life is easier when someone leads the way.

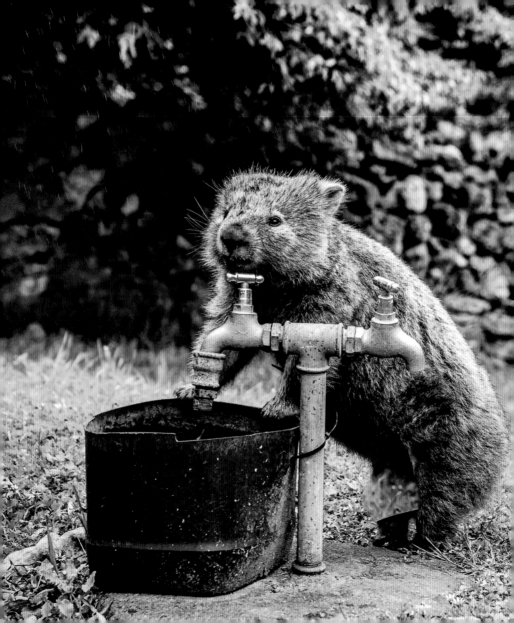

Hydrate, hydrate, hydrate.

Even on the busiest of days,
take a minute to stop, look
around and sniff the air.
Who knows where your
nose will lead you?

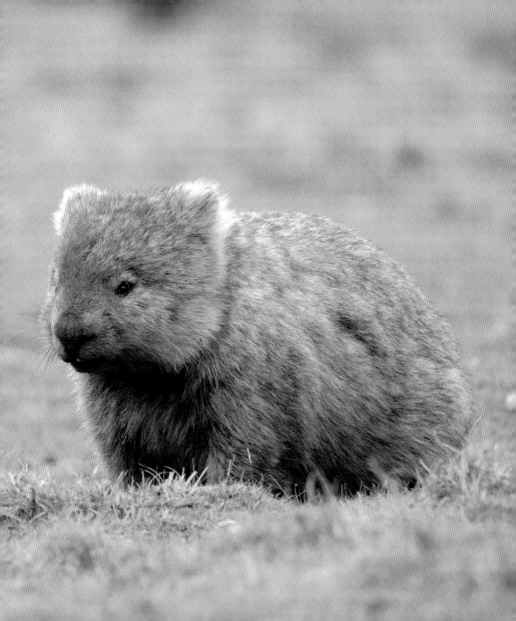

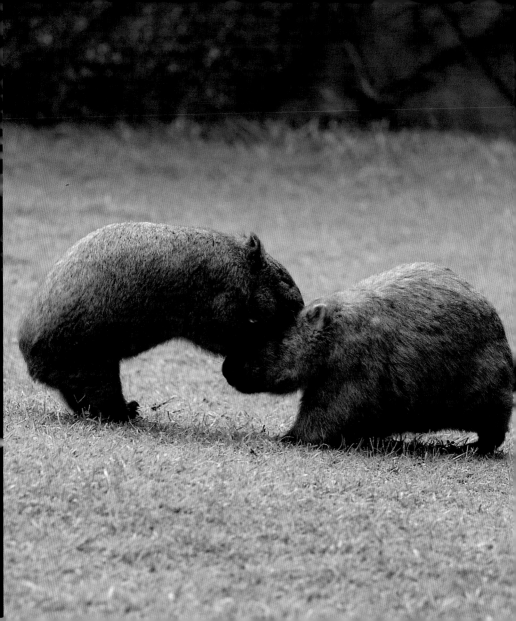

When you
find the one
who makes
you happy,
hang on to
them.

♥

Meditation is important in a long and happy life. A few minutes in the morning and again in the evening. And maybe just close your eyes every now and then during the day. You're not sleeping, you're ... meditating.

# Ommmm.

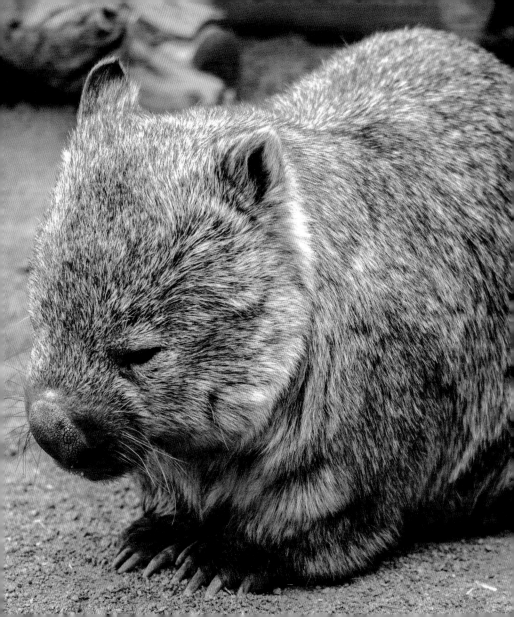

# Do what your mum tells you to do. She's usually right.

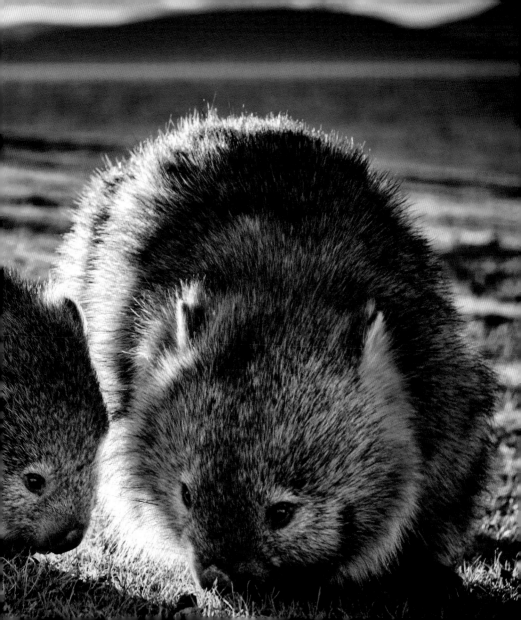

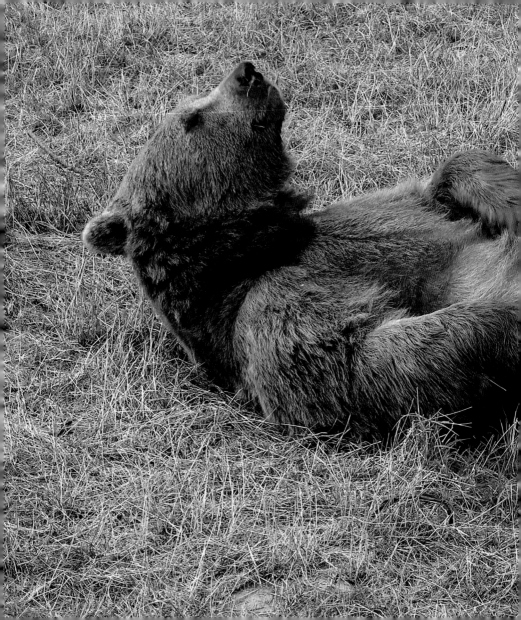

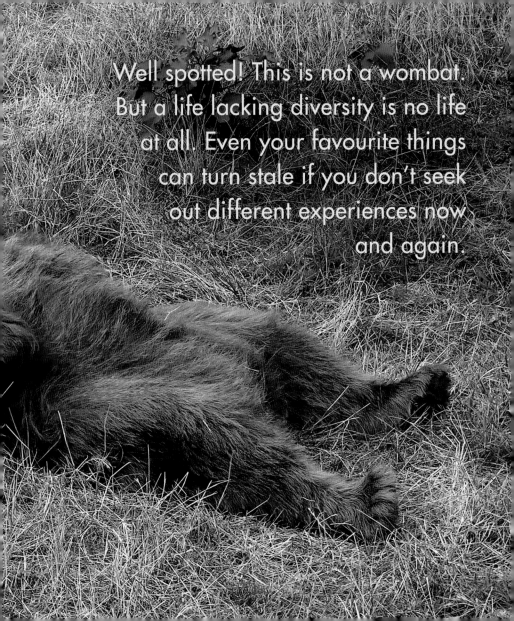

Well spotted! This is not a wombat. But a life lacking diversity is no life at all. Even your favourite things can turn stale if you don't seek out different experiences now and again.

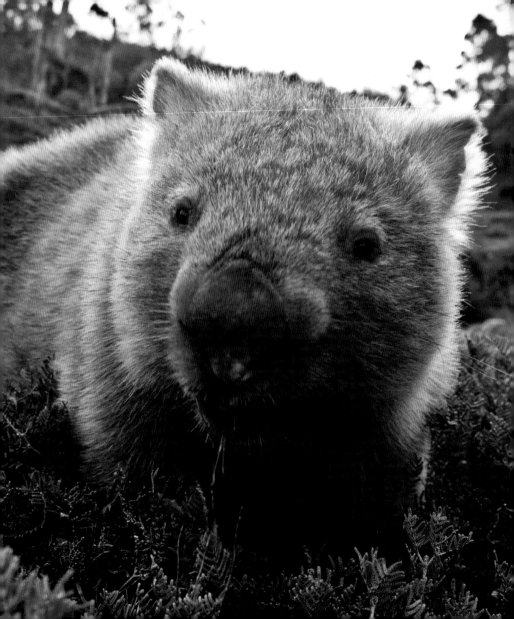

Laugh as much as possible. It will do you good. At least, you'll be more fun to be around.

Practise gratitude every day. It's good to be thankful for what you have.

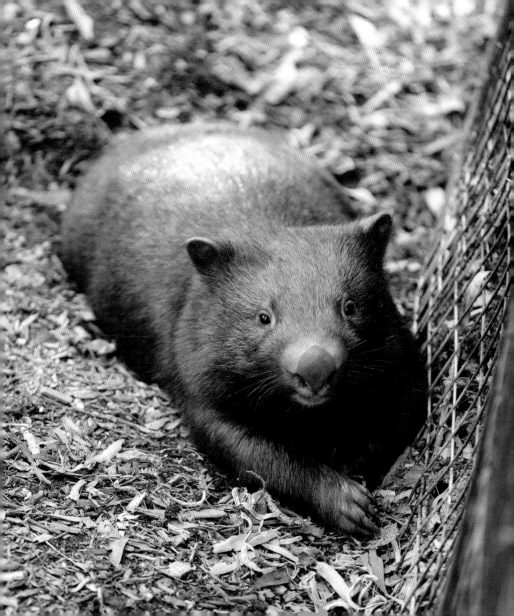

In the end, there's
no great mystery.
It's a truth both
infinitely complex
and undeniably
simple: life is what
we make of it.
Enjoy as much
of it as you can.

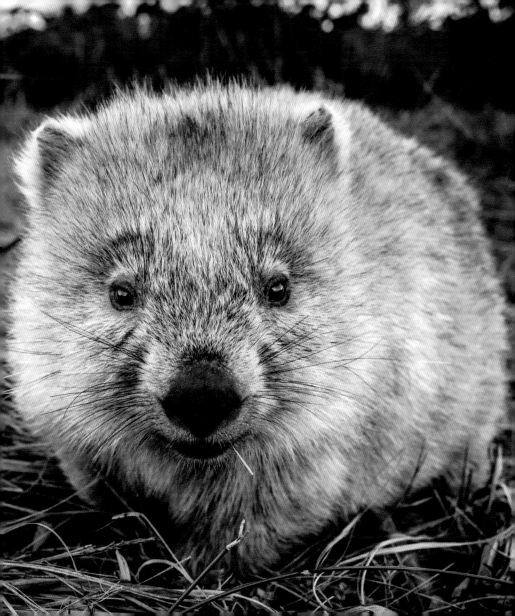

# Life is short, so make it sweet.

# Get happy.

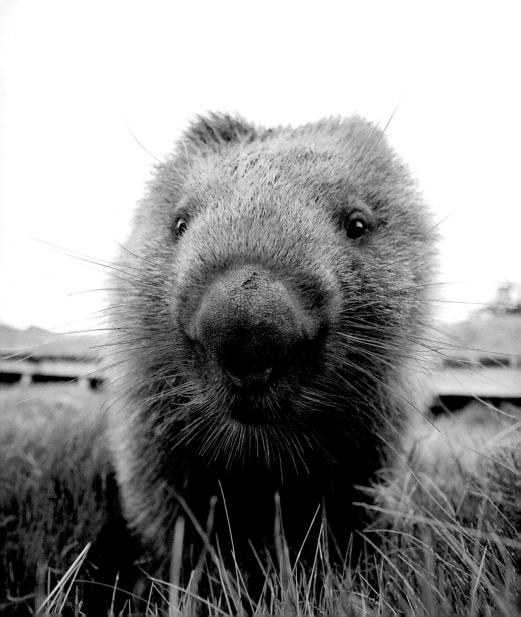

# wombat facts

### A group of wombats is called a 'wisdom' of wombats.

But you probably already guessed that from all the wisdom in this book!

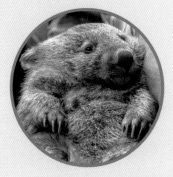

### Australia has three species of wombat, and they're all big-boned.

Most wombats grow to one metre long and weigh between 20–35 kilograms.

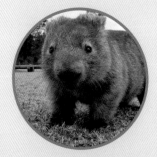

### Those tiny legs have some power in them.

They might walk with a waddle, but when they need to go, they go. Wombats have been clocked at speeds close to 40 kilometres per hour!

## A big-bottomed wombat named Fatso became an international sensation as an unofficial mascot of the Sydney 2000 Olympic Games.

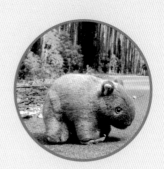

He caused a furore when it was rumoured the Australian Olympic Committee had told athletes like Suzie O'Neill and Grant Hackett not to bring him onto the winners' dais.

## Top-charting band The Wombats aren't even from Australia.

Though they've cracked Top 10 on the Hottest 100 and appeared on *Neighbours*, the trio actually comes from Liverpool, England.

## When wombats are relaxed, they'll sometimes kick back with their feet up in the air.

If you listen closely, you can probably even hear them snoring.

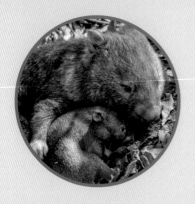

## Wombat mums keep their babies safe and clean inside specially evolved pouches.

While this supermum digs her warren, her backwards-facing pouch keeps dirt off her baby. Now that's parenting goals!

## You've heard wombats have cube-shaped poo, but did you know they use it to communicate?

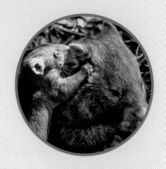

Wombats use their poo like we use notes on the fridge — only we make our notes sticky and they make their notes square.

## Australia once had wombats the size of rhinos, and their closest relative is the koala.

Diprotodons went extinct about 44,000 years ago, though scientists now believe they were more like cousins to the wombat than direct ancestors.

## Wombats, like many other Australian marsupials, glow in the dark.

Their nocturnal habits and penchant for bio-flourescence under UV light make wombats popular at rave parties.

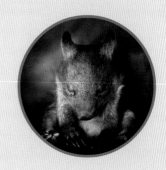

## The northern hairy-nosed wombat is one of the rarest animals in the world – in 1980 only 35 individuals remained in the world.

But the good news is, thanks to ongoing conservation efforts, this critically endangered species has increased its numbers tenfold in the last 40 years!

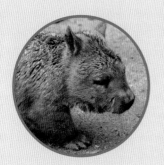

## Wombats like to use their ass-ets.

That big bottom is powerful in more ways than one. When threatened, a wombat will jump into its nearest burrow and use its armoured backside as a shield.

**HarperCollinsPublishers**

Australia • Brazil • Canada • France • Germany • Holland • India
Italy • Japan • Mexico • New Zealand • Poland • Spain • Sweden
Switzerland • United Kingdom • United States of America

HarperCollins acknowledges the Traditional Custodians
of the land upon which we live and work, and pays respect
to Elders past and present.

First published in Australia in 2022
by HarperCollins*Publishers* Australia Pty Limited
Gadigal Country
Level 13, 201 Elizabeth Street, Sydney NSW 2000
ABN 36 009 913 517
harpercollins.com.au

A catalogue record for this book is available from the National Library of Australia

ISBN 978 1 4607 6252 3 (hardback)
ISBN 978 1 4607 1516 1 (ebook)

Project editor: Shannon Kelly
Publisher: Catherine Milne
Cover and internal design by Shirley Tran, HarperCollins Design Studio
Front cover image by Sean Scott/Getty Images
Back cover images by Shutterstock.com
Images on pages 4, 129, 137 (Posnov/Getty Images), 17 (Brian Elliot/Alamy),
19 (Chris Ison/Alamy), 50 (Sean Kinsella/iStock), 65 (Su-Lin Lee/Getty Images),
73 (Courtesy Scott Carver), 120 (Joe Chelkowski), 122 (Jonas Eriksson/iStock),
132 (Jason Edwards/Getty Images), 135 (u3k/iStock), 139 (Sean Scott/Getty Images).
All other internal images by Shutterstock.com
Colour reproduction by Splitting Image Colour Studio, Clayton, Victoria
Printed and bound in China by RR Donnelley on 128gsm matt art
8 7 6 5 4 3 2 1    22 23 24 25